Wabi-Sabi

for Artists, Designers, Poets & Philosophers

Leonard Koren

Stone Bridge Press
Berkeley, California

Published by Stone Bridge Press
P.O. Box 8208, Berkeley, CA 94707, USA

Art direction and design by the author.

Printed in the United States of America.

ISBN 1-880656-12-4

Contents

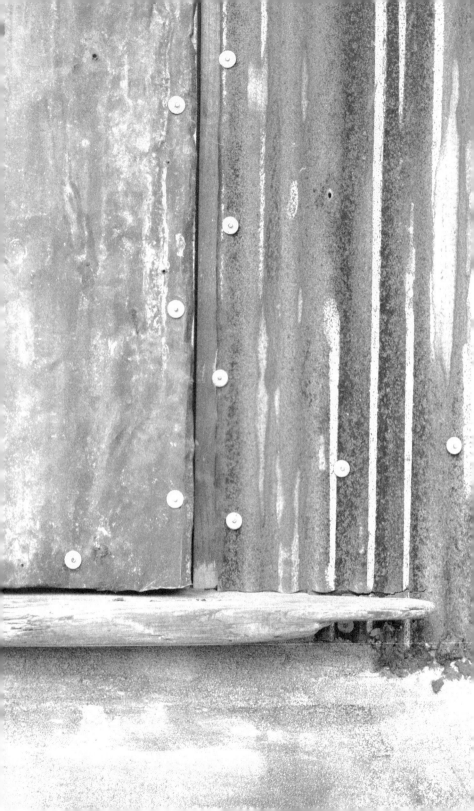

Introduction

Wabi-sabi is a beauty of things imperfect, impermanent, and incomplete.

It is a beauty of things modest and humble.

It is a beauty of things unconventional.

The extinction of a beauty. The immediate catalyst for this book was a widely publicized tea event in Japan. The Japanese aesthetic of wabi-sabi has long been associated with the tea ceremony, and this event promised to be a profound wabi-sabi experience. Hiroshi Teshigahara, the hereditary *iemoto* (grand master) of the Sogetsu school of flower arranging, had commissioned three of Japan's most famous and fashionable architects to design and build their conceptions of ceremonial tea-drinking environments. Teshigahara in addition would provide a fourth design.[1] After a three-plus-hour train and bus ride from my office in Tokyo, I arrived at the event site, the grounds of an old imperial summer residence. To my dismay I found a celebration of gorgeousness, grandeur, and elegant play, but hardly a trace of wabi-sabi. One slick tea hut, ostensibly made of paper, looked and smelled like a big

white plastic umbrella. Adjacent was a structure made of glass, steel, and wood that had all the intimacy of a highrise office building. The one tea house that approached the wabi-sabi qualities I had anticipated, upon closer inspection, was fussed up with gratuitous post-modern appendages. It suddenly dawned on me that wabi-sabi, once the preeminent high-culture Japanese aesthetic and the acknowledged centerpiece of tea, was becoming—had become?—an endangered species.[2]

Admittedly, the beauty of wabi-sabi is not to everyone's liking. But I believe it is in everyone's interest to prevent wabi-sabi from disappearing altogether. Diversity of the cultural ecology is a desirable state of affairs, especially in opposition to the accelerating trend toward the uniform digitalization of all sensory experience, wherein an electronic "reader" stands between experience and observation, and all manifestation is encoded identically.

In Japan, however, unlike Europe and to a lesser extent America, precious little material culture has been saved. So in Japan, saving a universe of beauty from extinction means, at

this late date, not merely preserving particular objects or buildings, but keeping a fragile aesthetic ideology alive in any form of expression available. Since wabi-sabi is not easily reducible to formulas or catch phrases without destroying its essence, saving it becomes a daunting task indeed.

Idealistic beauty. Like many of my contemporaries, I first learned of wabi-sabi during my youthful spiritual quest in the late 1960s. At that time, the traditional culture of Japan beckoned with profound "answers" to life's toughest questions. Wabi-sabi seemed to me a nature-based aesthetic paradigm that restored a measure of sanity and proportion to the art of living. Wabi-sabi resolved my artistic dilemma about how to create beautiful things without getting caught up in the dispiriting materialism that usually surrounds such creative acts. Wabi-sabi—deep, multi-dimensional, elusive—appeared the perfect antidote to the pervasively slick, saccharine, corporate style of beauty that I felt was desensitizing American society. I have since come to believe that wabi-sabi is related to many of the more emphatic anti-aesthetics that

invariably spring from the young, modern, creative soul: beat, punk, grunge, or whatever it's called next.

***The Book of Tea* redux.** I first read about wabi-sabi in Kakuzo (a.k.a. Tenshin) Okakura's enduring *The Book of Tea*, which had been published in 1906. Although Okakura touched on many aspects of wabi-sabi, he avoided using the term "wabi-sabi." He probably didn't want to confuse his readers with foreign words that were not absolutely essential to his discussion of aesthetic and cultural ideas. (The book was written in English for a non-Japanese audience.) He may also have avoided explicit mention of wabi-sabi because the concept is so full of thorny issues for the Japanese intellectual.

Almost a century after Okakura's book, however, the term "wabi-sabi" makes a perfunctory appearance in practically every book and magazine article that discusses the tea ceremony or other arcane things Japanese. Oddly enough, the two or three sentences used in these publications to describe wabi-sabi (the phrases at the beginning of this introduction) are almost always the same. And the

term is also used as a derisive shorthand by foreign and domestic critics to put down the sort of prissy dilettantism practiced by some devotees of Japan's traditional arts.

Perhaps now is an auspicious cultural moment to get beyond the standard definitions, to dive a little more deeply into the murky depths. In this spirit I have searched for the various pieces of wabi-sabi—tarnished, fragmented, and in disrepair though they may be—and have attempted to put them together into a meaningful system. I've gone as far as the orthodox wabi-sabi commentators, historians, and cultural authorities have ventured—and then I've taken a few steps further. Reading between the lines, matching intention to actuality, I have attempted to grasp the totality, the holism of wabi-sabi, and make some sense of it.[3]

The result, this skinny volume, is thus a tentative, personal first step toward "saving" what once constituted a comprehensive and clearly recognizable aesthetic universe.

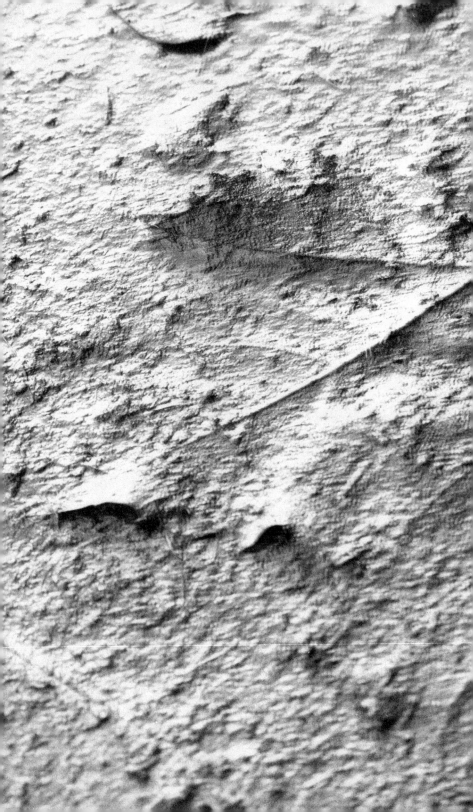

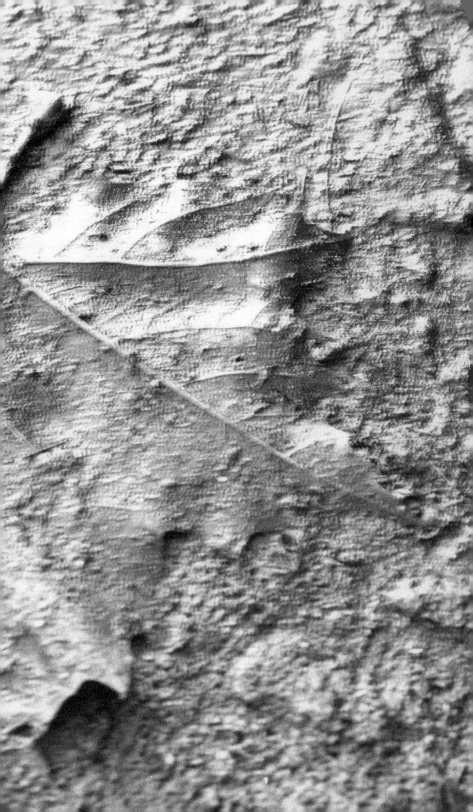

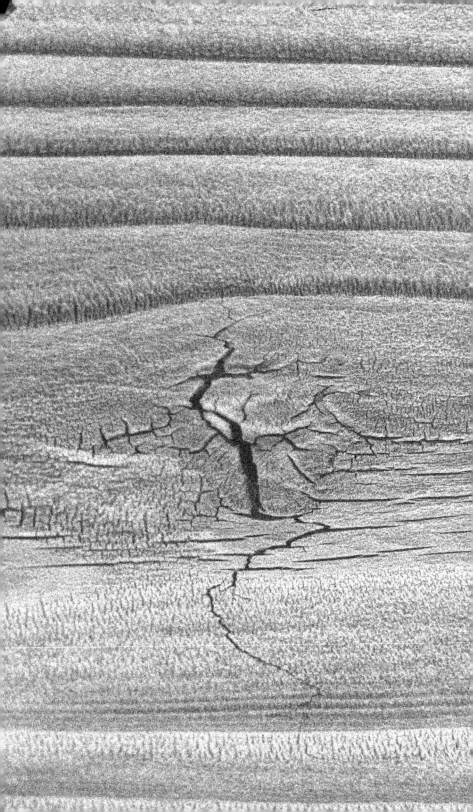

A History of Obfuscation

When asked what wabi-sabi is, most Japanese will shake their head, hesitate, and offer a few apologetic words about how difficult it is to explain. Although almost every Japanese will claim to understand the *feeling* of wabi-sabi—it is, after all, supposed to be one of the core concepts of Japanese culture—very few can articulate this feeling.

Why is this? Is it because, as some Japan chauvinists suggest, one needs the right genetic predisposition? Hardly. Is it because the Japanese language, or the conventions of its use, is good for communicating subtleties of mood, vagueness, and the logic of the heart, but not so good for explaining things in a rational way? In small part, perhaps. But the main reason is that most Japanese never learned about wabi-sabi in intellectual terms, since there are no books or teachers to learn it from.

This is not by accident. Throughout history a rational understanding of wabi-sabi has been intentionally thwarted.

Zen Buddhism. Almost since its inception as a distinct aesthetic mode, wabi-sabi has been peripherally associated with Zen Buddhism. In

many ways, wabi-sabi could even be called the "Zen of things," as it exemplifies many of Zen's core spiritual-philosophical tenets.[4] The first Japanese people involved with wabi-sabi—tea masters, priests, and monks—had all practiced Zen and were steeped in the Zen mindset. One of the major themes of Zen is strident anti-rationalism. Essential knowledge, in Zen doctrine, can be transmitted only from mind to mind, not through the written or spoken word. "Those who know don't say; those who say don't know." On a pragmatic level this precept is designed to reduce the misinter-pretation of easily misunderstood concepts. As a consequence, a clear, expository defini-tion of wabi-sabi has, for all intents and purposes, been studiously avoided.

The *iemoto* system. Since the 18th century, the organization and merchandising of cultural information in Japan about "arts" such as tea ceremony, flower arranging, calligraphy, song, and dance have been franchised out by what are essentially groups of family businesses. The chief family member in each group is called the *iemoto*.[5] Primary text sources, artifacts, and other materials needed for

scholarly research are often controlled by *iemoto* families who, as in Zen Buddhism, insist that such essential information be shared only with those of their choosing. The concept of wabi-sabi, a vital part of *iemoto* proprietary intellectual property (particularly in the world of tea), was not to be elucidated—given away—unless in exchange for money or favors. Artfully obscured "exotic" concepts like wabi-sabi also made good marketing bait. Obscuring the meaning of wabi-sabi, but tantalizing the consumer with glimpses of its value, was the most effective means of *iemoto*-style entrepreneurism.

Aesthetic obscurantism. Most revealing about the meaning of wabi-sabi is the fostering of the myth of inscrutability for aesthetic reasons. Some Japanese critics feel that wabi-sabi needs to maintain its mysterious and elusive—hard to define—qualities because ineffability is part of its specialness. Wabi-sabi is, they believe, a teleological benchmark—an end in itself—that can never be fully realized. From this vantage point, missing or indefinable knowledge is simply another aspect of wabi-sabi's inherent "incompleteness." Since ideological clarity or

transparency is not an essential aspect of wabi-sabi, to fully explain the concept might, in fact, diminish it.

Maybe these critics are correct. In the realm of aesthetics, reason is almost always subordinate to perception. Japanese sword makers and appraisers have traditionally talked about the aura-enshrouded "soul" of a blade in only the vaguest, most mystical terms. Nowadays, however, younger sword makers have studied and become quite clinical about the exact furnace temperatures, metal/chemical admixtures, and moment when the "nature"—the flexibility, rigidity, hardness, etc.—or "soul" of the blade is actually created. Perhaps this new-found candor deromanticizes something better left to the imagination. Yet if the ability to create the aesthetic is to be preserved, some guideposts need to be placed for future generations.

A Provisional Definition

Wabi-sabi is the most conspicuous and characteristic feature of what we think of as traditional Japanese beauty. It occupies roughly the same position in the Japanese pantheon of aesthetic values as do the Greek ideals of beauty and perfection in the West.[6] Wabi-sabi can in its fullest expression be a way of life. At the very least, it is a particular type of beauty.

The closest English word to wabi-sabi is probably "rustic." Webster's defines "rustic" as "simple, artless, or unsophisticated . . . [with] surfaces rough or irregular." While "rustic" represents only a limited dimension of the wabi-sabi aesthetic, it is the initial impression many people have when they first see a wabi-sabi expression. Wabi-sabi does share some characteristics with what we commonly call "primitive art," that is, objects that are earthy, simple, unpretentious, and fashioned out of natural materials. Unlike primitive art, though, wabi-sabi almost never is used representationally or symbolically.

Originally, the Japanese words "wabi" and "sabi" had quite different meanings. "Sabi" originally meant "chill," "lean," or "withered." "Wabi" originally meant the misery of living alone in nature, away from society, and

suggested a discouraged, dispirited, cheerless emotional state. Around the 14th century, the meanings of both words began to evolve in the direction of more positive aesthetic values. The self-imposed isolation and voluntary poverty of the hermit and ascetic came to be considered opportunities for spiritual richness. For the poetically inclined, this kind of life fostered an appreciation of the minor details of everyday life and insights into the beauty of the inconspicuous and overlooked aspects of nature. In turn, unprepossessing simplicity took on new meaning as the basis for a new, pure beauty.

Over the intervening centuries the meanings of wabi and sabi have crossed over so much that today the line separating them is very blurry indeed. When Japanese today say "wabi" they also mean "sabi," and vice-versa. Most often people simply say "wabi-sabi," the convention adopted for this book. But if we were to consider wabi and sabi as separate entities, we could characterize their differences as follows:

wabi refers to	sabi refers to
▪ a way of life, a spiritual path	▪ material objects, art and literature
▪ the inward, the subjective	▪ the outward, the objective
▪ a philosophical construct	▪ an aesthetic ideal
▪ spatial events	▪ temporal events

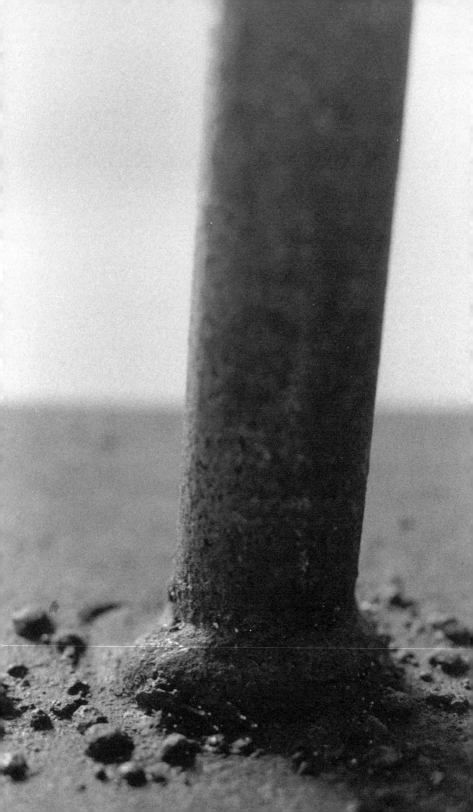

A Comparison
with Modernism

To get a better sense of what wabi-sabi is—
and isn't—it might be helpful to compare and
contrast it with modernism, the dominant
aesthetic sensibility of mid- to late-20th-
century international industrialized society.
"Modernism" is another slippery term that cuts
a wide swath across art and design history,
attitudes, and philosophy. Here we will
describe "middle" modernism, the kind of
modernism embodied in most of the pieces of
the permanent collection of the Museum of
Modern Art in New York. Middle modernism
includes most of the slick, minimalist
appliances, machines, automobiles, and
gadgets produced since the Second World War.
It also includes concrete, steel, and glass box
buildings of the sort that houses the Museum
of Modern Art itself.

Similarities.

■ Both apply to all manner of manmade
objects, spaces, and designs.

■ Both are strong reactions against the
dominant, established sensibilities of their
time. Modernism was a radical departure from

19th-century classicism and eclecticism. Wabi-sabi was a radical departure from the Chinese perfection and gorgeousness of the 16th-century and earlier.

- Both eschew any decoration that is not integral to structure.

- Both are abstract, nonrepresentational ideals of beauty.

- Both have readily identifiable surface characteristics. Modernism is seamless, polished, and smooth. Wabi-sabi is earthy, imperfect, and variegated.

Differences.[7]

modernism	*wabi-sabi*
Primarily expressed in the public domain	Primarily expressed in the private domain
Implies a logical, rational worldview	Implies an intuitive worldview
Absolute	Relative

Looks for universal, prototypical solutions	Looks for personal, idiosyncratic solutions
Mass-produced/ modular	One-of-a-kind/ variable
Expresses faith in progress	There is no progress
Future-oriented	Present-oriented
Believes in the control of nature	Believes in the fundamental uncontrollability of nature
Romanticizes technology	Romanticizes nature
People adapting to machines	People adapting to nature
Geometric organization of form (sharp, precise, definite shapes and edges)	Organic organization of form (soft, vague shapes and edges)

modernism	*wabi-sabi*
The box as metaphor (rectilinear, precise, contained)	The bowl as metaphor (free shape, open at top)
Manmade materials	Natural materials
Ostensibly slick	Ostensibly crude
Needs to be well-maintained	Accommodates to degradation and attrition
Purity makes its expression richer	Corrosion and contamination make its expression richer
Solicits the reduction of sensory information	Solicits the expansion of sensory information
Is intolerant of ambiguity and contradiction	Is comfortable with ambiguity and contradiction

Cool	Warm
Generally light and bright	Generally dark and dim
Function and utility are primary values	Function and utility are not so important
Perfect materiality is an ideal	Perfect immateriality is an ideal
Everlasting	To every thing there is a season

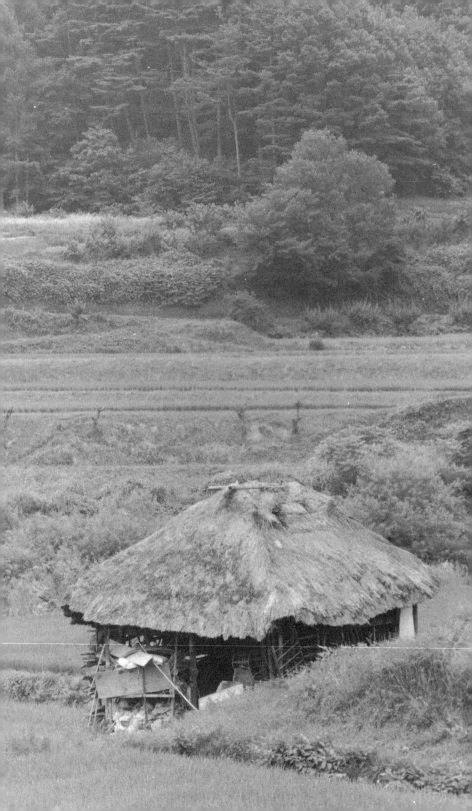

A Brief History

Pre-Rikyu. The initial inspirations for wabi-sabi's metaphysical, spiritual, and moral principles come from ideas about simplicity, naturalness, and acceptance of reality found in Taoism and Chinese Zen Buddhism. The wabi-sabi state of mind and sense of materiality both derive from the atmosphere of desolation and melancholy and the expression of minimalism in 9th- and 10th-century Chinese poetry and monochromatic ink painting. By the late 16th century, however, these separate elements of wabi-sabi had coalesced into an identifiably Japanese synthesis. Although wabi-sabi quickly permeated almost every aspect of sophisticated Japanese culture and taste, it reached its most comprehensive realization within the context of the tea ceremony.

Variously called *sado*, *chado*, and *chanoyu*, the tea ceremony as it evolved became an eclectic social art form combining, among other things, the skills of architecture, interior and garden design, flower arranging, painting, food preparation, and performance. The accomplished tea practitioner was some-one who could orchestrate all these elements—and the guests in attendance—into a quietly exciting artistic event that thematically

cohered.[8] At its artistic zenith, realizing the universe of wabi-sabi in its fullness was the underlying goal of tea.

The first recorded wabi-sabi tea master was Murata Shuko (a.k.a. Murata Juko, 1423–1502), a Zen monk from Nara. Around this time in secular society, tea had become an elite pastime indulged in, in no small part, because of the prestige associated with ownership of elegant foreign-made tea-related objects.[9] Shuko, in opposition to this fashion, used intentionally understated, locally produced utensils whenever possible. This was the beginning of the wabi-sabi aesthetic in tea.

Rikyu. About a hundred years after Shuko's innovation, wabi-sabi was brought to its apotheosis by Sen no Rikyu (1522–1591). The son of a merchant, Rikyu developed an interest in tea at age seventeen.[10] Rikyu's first noted service as a tea master was to the powerful military ruler Oda Nobunaga. After Nobunaga's assassination in 1582, Rikyu entered the service of his successor, the brilliant and eccentric Toyotomi Hideyoshi. Rikyu, along with nine other tea masters, helped Hideyoshi

by procuring and appraising tea-related objects and by interpreting the complex protocol of tea and tea utensils used in formal situations. Although the late 16th century was a period of almost continuous warfare, it was also a time of great creativity and invention in the arts. In tea there was considerable experimentation with objects, architectural space, and the ritual itself. It was in the midst of this cultural flux that Rikyu secured his most enduring aesthetic triumph: to unequivocally place crude, anonymous, indigenous Japanese and Korean folkcraft—things wabi-sabi—on the same artistic level, or even higher than, slick, perfect, Chinese treasures.[11] Rikyu also created a new kind of tea room based on the prototype of a farmer's hut of rough mud walls, thatched roof, and misshapen exposed wood structural elements. Rikyu then compressed this room down to an astounding two tatami mats, a mere thirty-nine square feet.[12]

Unfortunately, Rikyu's turn toward simple, modest, and natural values was not well appreciated by his employer. Hideyoshi, a man of peasant origins, was suspicious of Rikyu's taste for what could also be called the ugly and the obscure. Was Rikyu cynically offering

the emperor some new clothes? Hideyoshi's aesthetic ideal, it should be noted, was the ultimate expression of Chinese gorgeousness: the gold-leafed tea room. Rikyu's aesthetic challenge created a rift in their relationship that, among other things—Hideyoshi's jealousy of Rikyu's growing acclaim, Rikyu's political indiscretions and tea utensil profiteering—finally prompted Hideyoshi to order Rikyu's ritual suicide at the age of seventy.

Post-Rikyu. A major preoccupation of organized tea factions ever since Rikyu's death has been to establish their legitimacy based on their supposed direct links to his true teachings (not unlike religious fundamentalists claiming theirs to be the correct interpretation of the intentions of Christ or Mohammed).[13] In the process, personal judgment and imagination have been pretty much wrung out of tea. Even the most minute hand gestures of the ritual are rigidly prescribed, allegedly deriving unchanged from Rikyu's time (the rationale here being that Rikyu had already arrived at the most rational way of using each utensil with a minimum expenditure of energy and wasted motion).

Approximately one hundred years after Rikyu's death, the "art" of tea was repositioned into the "way" of tea (*chado*), ostensibly a form of religious and spiritual training. During this transformation, wabi-sabi, the core of "spiritual" tea, was reduced, simplified, and packaged into a definitive set of rules and sayings. Wabi-sabi was well on its way to becoming its opposite: slick, polished, and gorgeous.

On the plus side, the institutionalized tea schools heir to this history can be said to be living museums that maintain the consistency of the traditional forms. (Repetition is, after all, the essence of tradition.) It can also be said that if not for the tea schools, wabi-sabi—what's left of it—would wane even faster than it has in the face of Japan's frenzied Western-style modernization. Also, institutionalized tea practice still has value as a meditation exercise. Nonthinking repetition of mechanical forms allows one to concentrate simply on *being* without the distraction of having to make decisions, artistic or otherwise.[14]

Nevertheless, wabi-sabi is no longer the true ideological or spiritual linchpin of tea, even though things that sound like wabi-sabi and look like wabi-sabi—the correct words and

the stylized forms—are still trotted out. Instead, wabi-sabi has been supplanted by the tea schools' focus on "world peace" and "deep communication between people."[15] As a long-delayed reaction to the absence of genuine wabi-sabi, a few progressive members of the tea orthodoxy have recently enlisted the aid of contemporary artists and designers in an attempt to reinvigorate the wabi-sabi connection.[16] The philosophical basis of this "new" wabi-sabi is a Rikyu reformulation of an old Zen maxim, "First [tea] meeting, last [tea] meeting," meaning that you must pay maximum attention to everything happening at this very moment: be here now. Whether this particular moral-spiritual tangent will prove fruitful in guiding tea into more wabi-sabi-like directions remains to be seen.[17]

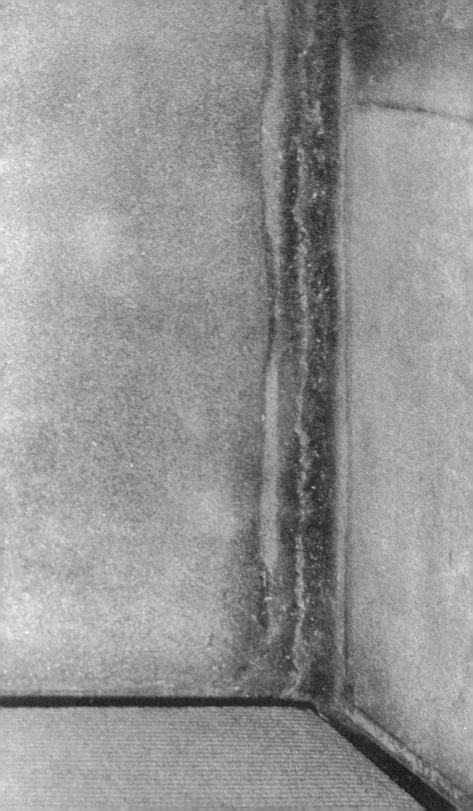

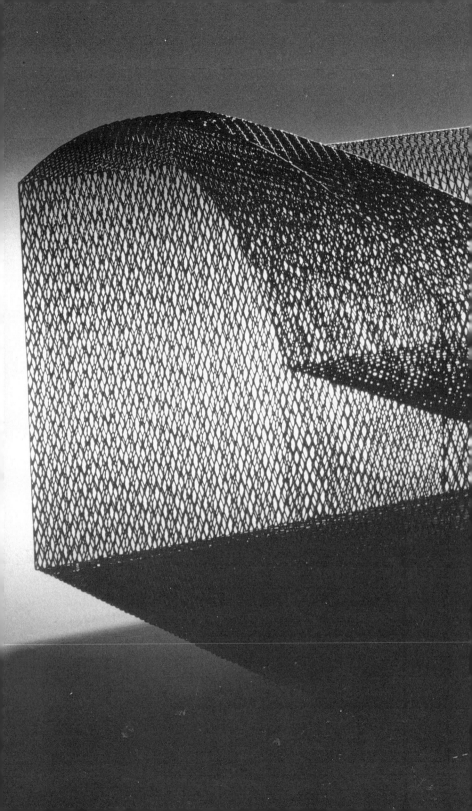

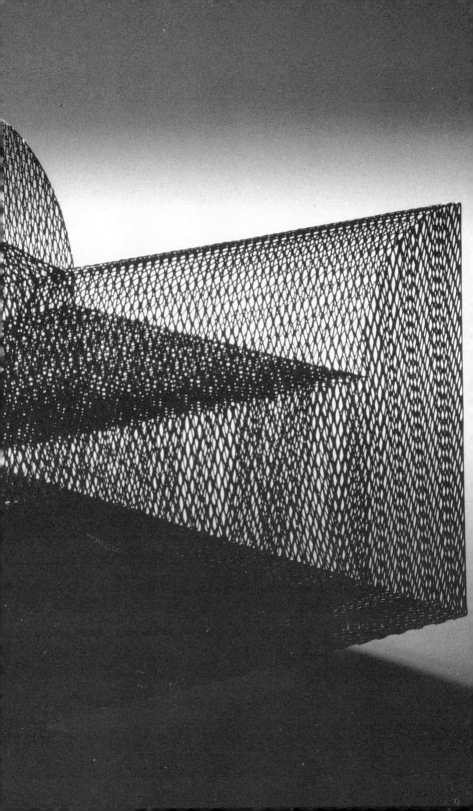

The Wabi-Sabi Universe

Metaphysical Basis

- Things are either devolving toward, or evolving from, nothingness

Spiritual Values

- Truth comes from the observation of nature

- "Greatness" exists in the inconspicuous and overlooked details

- Beauty can be coaxed out of ugliness

State of Mind

- Acceptance of the inevitable

- Appreciation of the cosmic order

Moral Precepts

- Get rid of all that is unnecessary

- Focus on the intrinsic and ignore material hierarchy

Material Qualities

- The suggestion of natural process

- Irregular

- Intimate

- Unpretentious

- Earthy

- Murky

- Simple

Wabi-sabi can be called a "comprehensive" aesthetic system. Its world view, or universe, is self-referential. It provides an integrated approach to the ultimate nature of existence (metaphysics), sacred knowledge (spirituality), emotional well-being (state of mind), behavior (morality), and the look and feel of things (materiality).[18] The more systematic and clearly defined the components of an aesthetic system are— the more conceptual handles, the more ways it refers back to fundamentals—the more useful it is.

The Metaphysical Basis of Wabi-Sabi

What is the universe like?

Things are either devolving toward, or evolving from, nothingness. As dusk approaches in the hinterlands, a traveler ponders shelter for the night. He notices tall rushes growing everywhere, so he bundles an armful together as they stand in the field, and knots them at the top. Presto, a living grass hut. The next morning, before embarking on another day's journey, he unknots the rushes and presto, the hut de-constructs, disappears, and becomes a virtually indistinguishable part of the larger field of rushes once again. The original wilderness seems to be restored, but minute traces of the shelter remain. A slight twist or bend in a reed here and there. There is also the memory of the hut in the mind of the traveler—and in the mind of the reader reading this description. Wabi-sabi, in its purest, most idealized form, is precisely about these delicate traces, this faint evidence, at the borders of nothingness.[19]

While the universe destructs it also constructs. New things emerge out of nothingness. But we can't really determine by cursory observation whether something is in the

evolving or devolving mode. If we didn't know differently we might mistake the newborn baby boy—small, wrinkled, bent, a little grotesque looking—for the very old man on the brink of death. In representations of wabi-sabi, arbitrarily perhaps, the devolving dynamic generally tends to manifest itself in things a little darker, more obscure, and quiet. Things evolving tend to be a little lighter and brighter, a bit clearer, and slightly more eye-arresting. And nothingness itself—instead of being empty space, as in the West—is alive with possibility. In metaphysical terms, wabi-sabi suggests that the universe is in constant motion toward or away from potential.

Wabi-Sabi Spiritual Values

What are the lessons of the universe?

Truth comes from the observation of nature.[20] The Japanese have tried to control nature where they could, as best they could, within the limits of available technology. But there was little they could do about the weather— hot and humid summers, cold and dry winters, and rain on the average of one out of every three days throughout the year, except during the rainy season in early summer when everything is engulfed in a fine wet mist for six to eight weeks. And there was little they could do about the earthquakes, volcanic eruptions, typhoons, floods, fires, and tidal waves that periodically and unpredictably visited their land. The Japanese didn't particularly trust nature, but they learned from it. Three of the most obvious lessons gleaned from millennia of contact with nature (and leavened with Taoist thought) were incorporated into the wisdom of wabi-sabi.

1. *All things are impermanent.* The inclination toward nothingness is unrelenting and universal. Even things that have all the earmarks of substance—things that are hard, inert, solid—

present nothing more than the *illusion* of permanence. We may wear blinders, use ruses to forget, ignore, or pretend otherwise—but all comes to nothing in the end. Everything wears down. The planets and stars, and even intangible things like reputation, family heritage, historical memory, scientific theorems, mathematical proofs, great art and literature (even in digital form)—all eventually fade into oblivion and nonexistence.

2. *All things are imperfect*. Nothing that exists is without imperfections. When we look really closely at things we see the flaws. The sharp edge of a razor blade, when magnified, reveals microscopic pits, chips, and variegations. Every craftsman knows the limits of perfection: the imperfections glare back. And as things begin to break down and approach the primordial state, they become even less perfect, more irregular.

3. *All things are incomplete*. All things, including the universe itself, are in a constant, neverending state of becoming or dissolving. Often we arbitrarily designate moments, points along the way, as "finished" or "complete." But when

does something's destiny finally come to fruition? Is the plant complete when it flowers? When it goes to seed? When the seeds sprout? When everything turns into compost? The notion of completion has no basis in wabi-sabi.

"Greatness" exists in the inconspicuous and overlooked details. Wabi-sabi represents the exact opposite of the Western ideal of great beauty as something monumental, spectacular, and enduring. Wabi-sabi is not found in nature at moments of bloom and lushness, but at moments of inception or subsiding. Wabi-sabi is not about gorgeous flowers, majestic trees, or bold landscapes. Wabi-sabi is about the minor and the hidden, the tentative and the ephemeral: things so subtle and evanescent they are invisible to vulgar eyes.

Like homeopathic medicine, the essence of wabi-sabi is apportioned in small doses. As the dose decreases, the effect becomes more potent, more profound. The closer things get to nonexistence, the more exquisite and evocative they become. Consequently to experience wabi-sabi means you have to slow way down, be patient, and look very closely.[21]

Beauty can be coaxed out of ugliness.

Wabi-sabi is ambivalent about separating beauty from non-beauty or ugliness. The beauty of wabi-sabi is, in one respect, the condition of coming to terms with what you consider ugly. Wabi-sabi suggests that beauty is a dynamic event that occurs between you and something else. Beauty can spontaneously occur at any moment given the proper circumstances, context, or point of view. Beauty is thus an altered state of consciousness, an extraordinary moment of poetry and grace.

To the wealthy merchants, samurai, and aristocrats who practiced tea, a medieval Japanese farmer's hut, which the wabi-sabi tea room was modeled on, was a quite lowly and miserable environment. Yet, in the proper context, with some perceptual guidance, it took on exceptional beauty. Similarly, early wabi-sabi tea utensils were rough, flawed, and of undistinguished muddy colors. To tea people accustomed to the Chinese standards of refined, gorgeous, and perfect beauty, they were initially perceived as ugly. It is almost as if the pioneers of wabi-sabi intentionally looked for such examples of the

conventionally not-beautiful—homely but not excessively grotesque—and created challenging situations where they would be transformed into their opposite.

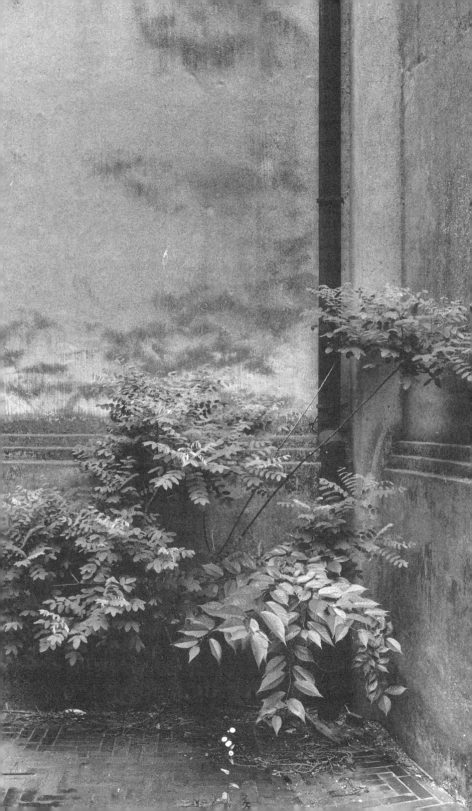

The Wabi-Sabi
State of Mind

How do we feel about what we know?

Acceptance of the inevitable. Wabi-sabi is an aesthetic appreciation of the evanescence of life. The luxuriant tree of summer is now only withered branches under a winter sky. All that remains of a splendid mansion is a crumbled foundation overgrown with weeds and moss. Wabi-sabi images force us to contemplate our own mortality, and they evoke an existential loneliness and tender sadness. They also stir a mingled bittersweet comfort, since we know all existence shares the same fate.

The wabi-sabi state of mind is often communicated through poetry, because poetry lends itself to emotional expression and strong, reverberating images that seem "larger" than the small verbal frame that holds them (thus evoking the larger universe). Rikyu used this oft-repeated poem by Fujiwara no Teika (1162–1241) to describe the mood of wabi-sabi:

All around, no flowers in bloom

Nor maple leaves in glare,

A solitary fisherman's hut alone

On the twilight shore

Of this autumn eve.[22]

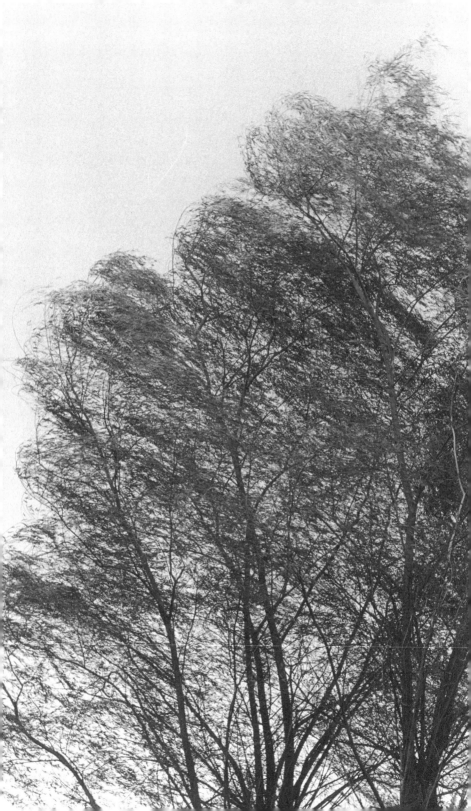

Certain common sounds also suggest the sad-beautiful feeling of wabi-sabi. The mournful quarks and caws of seagulls and crows. The forlorn bellowing of foghorns. The wails of ambulance sirens echoing through canyons of big city buildings.

Appreciation of the cosmic order. Wabi-sabi suggests the subtlest realms and all the mechanics and dynamics of existence, way beyond what our ordinary senses can perceive. These primordial forces are evoked in everything wabi-sabi in much the same way that Hindu mandalas or medieval European cathedrals were constructed to emotionally convey their respective cosmic schemes. The materials out of which things wabi-sabi are made elicit these transcendent feelings. The way rice paper transmits light in a diffuse glow. The manner in which clay cracks as it dries. The color and textural metamorphosis of metal when it tarnishes and rusts. All these represent the physical forces and deep structures that underlie our everyday world.

Wabi-Sabi Moral Precepts

Knowing what we know, how should we act?

Get rid of all that is unnecessary. Wabi-sabi means treading lightly on the planet and knowing how to appreciate whatever is encountered, no matter how trifling, whenever it is encountered. "Material poverty, spiritual richness" are wabi-sabi bywords. In other words, wabi-sabi tells us to stop our preoccupation with success—wealth, status, power, and luxury—and enjoy the unencumbered life.

Obviously, leading the simple wabi-sabi life requires some effort and will and also some tough decisions. Wabi-sabi acknowledges that just as it is important to know when to make choices, it is also important to know when *not* to make choices: to let things be. Even at the most austere level of material existence, we still live in a world of things. Wabi-sabi is exactly about the delicate balance between the pleasure we get from things and the pleasure we get from freedom from things

Focus on the intrinsic and ignore material hierarchy. The behavior prescribed for the wabi-sabi tea room is a clear expression of wabi-sabi values. First, as a symbolic act of

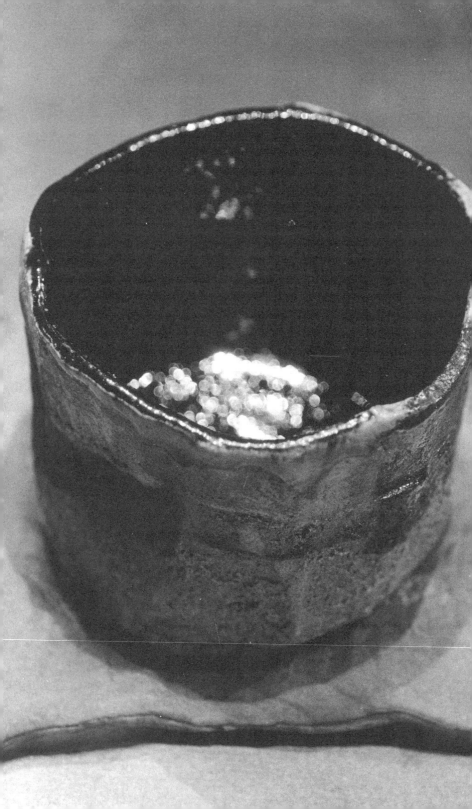

humility, everyone either bends or crawls to enter the tea room through an entrance purposely designed low and small. Once inside, the atmosphere is egalitarian. Hierarchical thinking—"this is higher/better, that is lower/worse"—is not acceptable. The poor student, the wealthy business person, and the powerful religious leader—distinctly different social classes on the outside—are equals within. Similarly, to the sensitive observer, the essential qualities of the objects inside the tea room are either obvious or they are not. Conventional aids to discernment, like the origins and names of the object makers, are of no wabi-sabi consequence. The normal hierarchy of material value related to cost is also pushed aside. Mud, paper, and bamboo, in fact, have more intrinsic wabi-sabi qualities/value than do gold, silver, and diamonds. In wabi-sabi, there is no "valuable," since that would imply "not valuable." An object obtains the state of wabi-sabi only for the moment it is appreciated as such.[23] In the tea room, therefore, things come into existence only when they express their wabi-sabi qualities. Outside the tea room, they return to their ordinary reality, and their wabi-sabi existence fades away.

The Material Qualities of Wabi-Sabi

What objects/motifs/juxtapositions express our understanding of the universe, or create that understanding in others?

The suggestion of natural process. Things wabi-sabi are expressions of time frozen. They are made of materials that are visibly vulnerable to the effects of weathering and human treatment. They record the sun, wind, rain, heat, and cold in a language of discoloration, rust, tarnish, stain, warping, shrinking, shriveling, and cracking. Their nicks, chips, bruises, scars, dents, peeling, and other forms of attrition are a testament to histories of use and misuse. Though things wabi-sabi may be on the point of dematerialization (or materialization)—extremely faint, fragile, or desiccated—they still possess an undiminished poise and strength of character.

Irregular. Things wabi-sabi are indifferent to conventional good taste. Since we already know what the "correct" design solutions are, wabi-sabi thoughtfully offers the "wrong" solutions.[24] As a result, things wabi-sabi often appear odd, misshapen, awkward, or what many people would consider ugly. Things

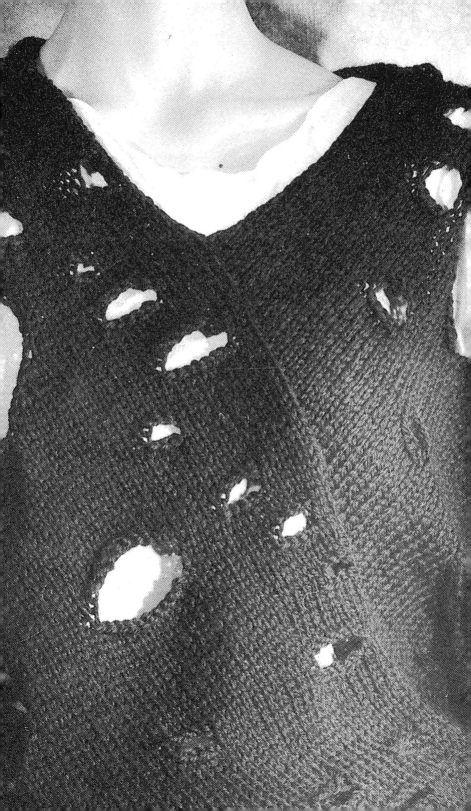

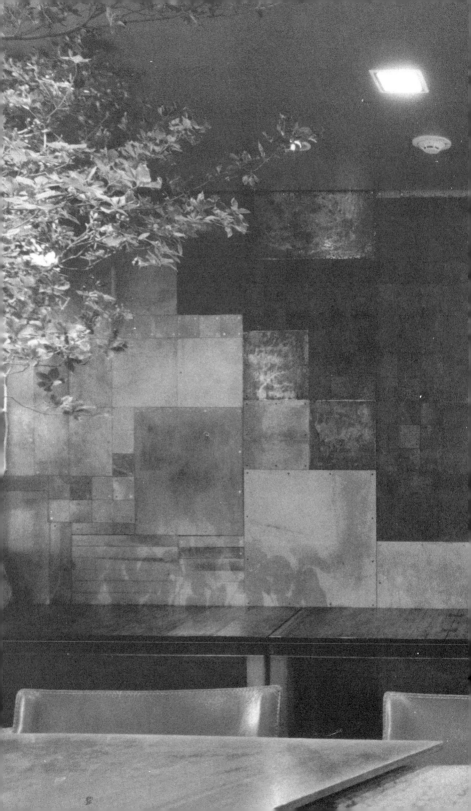

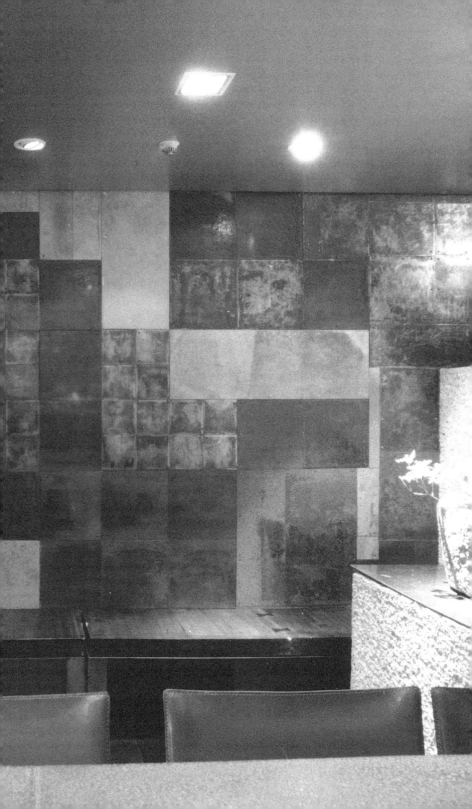

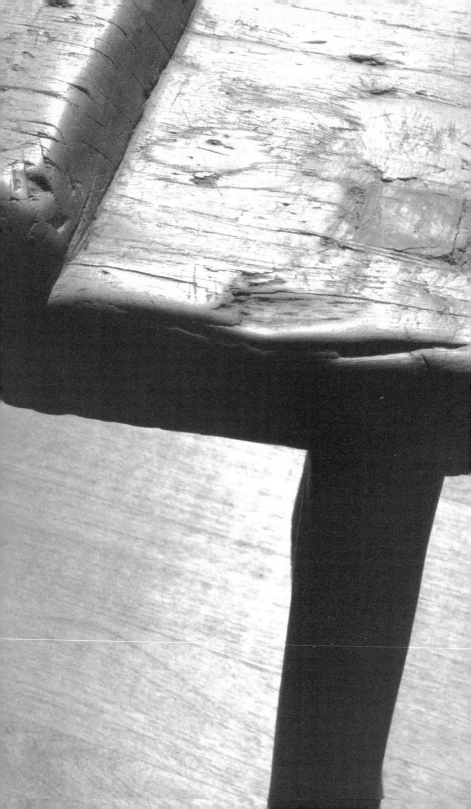

wabi-sabi may exhibit the effects of accident, like a broken bowl glued back together again. Or they may show the result of just letting things happen by chance, like the irregular fabrics that are created by intentionally sabotaging the computer program of a textile loom.

Intimate. Things wabi-sabi are usually small and compact, quiet and inward-oriented. They beckon: get close, touch, relate. They inspire a reduction of the psychic distance between one thing and another thing; between people and things.

Places wabi-sabi are small, secluded, and private environments that enhance one's capacity for metaphysical musings. Wabi-sabi tea rooms, for example, may have fewer than a hundred square feet of floor space. They have low ceilings, small windows, tiny entrances, and very subdued lighting. They are tranquil and calming, enveloping and womb-like. They are a world apart: nowhere, anywhere, everywhere. Within the tea room, as within all places wabi-sabi, every single object seems to expand in importance in inverse proportion to its actual size.[25]

Unpretentious. Things wabi-sabi are unstudied and inevitable looking. They do not blare out "I am important" or demand to be the center of attention. They are understated and unassuming, yet not without presence or quiet authority. Things wabi-sabi easily coexist with the rest of their environment.[26]

Things wabi-sabi are appreciated only during direct contact and use; they are never locked away in a museum. Things wabi-sabi have no need for the reassurance of status or the validation of market culture. They have no need for documentation of provenance. Wabi-sabi-ness in no way depends on knowledge of the creator's background or personality. In fact, it is best if the creator is of no distinction, invisible, or anonymous.

Earthy. Things wabi-sabi can appear coarse and unrefined. They are usually made from materials not far removed from their original condition within, or upon, the earth and are rich in raw texture and rough tactile sensation. Their craftsmanship may be impossible to discern.

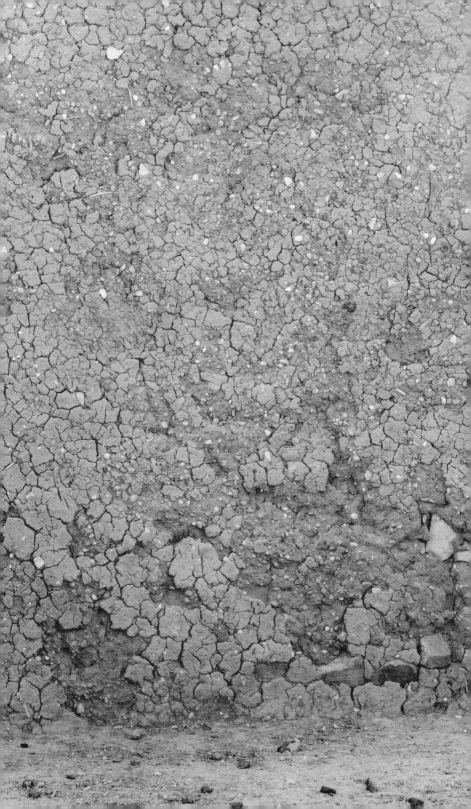

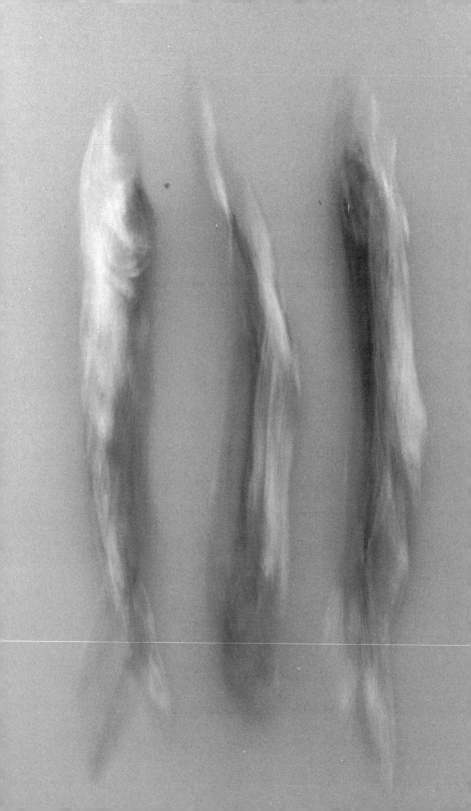

Murky. Things wabi-sabi have a vague, blurry, or attenuated quality—as things do as they approach nothingness (or come out of it). Once-hard edges take on a soft pale glow. Once-substantial materiality appears almost sponge-like. Once-bright saturated colors fade into muddy earth tones or the smoky hues of dawn and dusk. Wabi-sabi comes in an infinite spectrum of grays: gray-blue brown, silver-red grayish black, indigo yellowish-green. . . . And browns: blackish deep brown-tinged blue, muted greens. . . . And blacks: red black, blue black, brown black, green black. . . .

Less often, things wabi-sabi can also come in the light, almost pastel colors associated with a recent emergence from nothingness. Like the off-whites of unbleached cotton, hemp, and recycled paper. The silver-rusts of new saplings and sprouts. The green-browns of tumescent buds.

Simple. Simplicity is at the core of things wabi-sabi. Nothingness, of course, is the ultimate simplicity. But before and after nothingness, simplicity is not so simple. To paraphrase Rikyu, the essence of wabi-sabi, as expressed in tea, is simplicity itself: fetch water, gather

firewood, boil the water, prepare tea, and serve it to others. Further details, Rikyu suggests, are left to one's own invention.

But how do you exercise the restraint that simplicity requires without crossing over into ostentatious austerity? How do you pay attention to all the necessary details without becoming excessively fussy? How do you achieve simplicity without inviting boredom?

The simplicity of wabi-sabi is probably best described as the state of grace arrived at by a sober, modest, heartfelt intelligence. The main strategy of this intelligence is economy of means. Pare down to the essence, but don't remove the poetry. Keep things clean and unencumbered, but don't sterilize. (Things wabi-sabi are emotionally warm, never cold.) Usually this implies a limited palette of materials. It also means keeping conspicuous features to a minimum. But it doesn't mean removing the invisible connective tissue that somehow binds the elements into a meaning-ful whole. It also doesn't mean in any way diminishing something's "interestingness," the quality that compels us to look at that something over, and over, and over again.

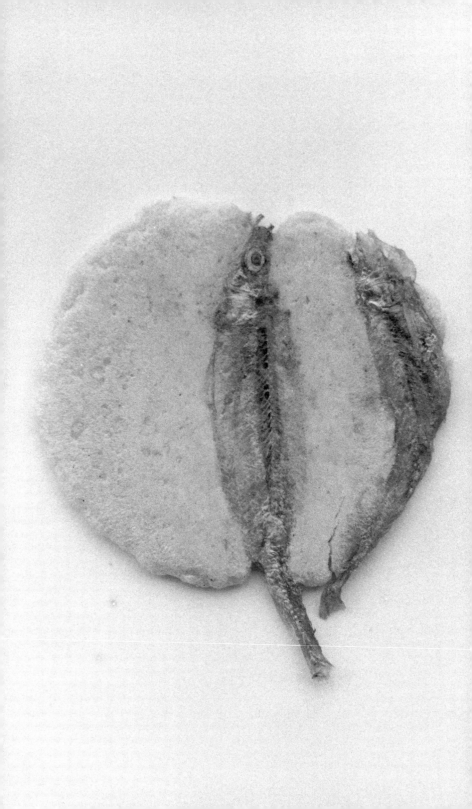

Text Notes

1. Besides an outdoor bamboo environment by Teshigahara, the other tea-drinking structures were designed by Tadao Ando, Arata Isozaki, and Kiyonori Kikutake. The event was called "The Great Numazu Tea Event," an explicit allusion to the "Big Tea Gathering at Kitano Shrine" of October 1587, the largest-scale tea event ever held in Japan. The warlord Toyotomi Hideyoshi, having just conquered the southern island of Kyushu, issued a proclamation commanding all practitioners of tea, rich and poor alike, to attend his event at Kitano Shrine in Kyoto. Some 800 tea huts filled the pine groves on the shrine grounds.

2. Throughout this book the term "aesthetic" refers to a set of informing values and principles—guidelines—for making artistic discriminations and decisions. The hallmarks of an "aesthetic" are (1) distinctiveness (distinction from the mass of ordinary, chaotic, non-differentiated perceptions), (2) clarity (the aesthetic *point* has to be definite—clear—even if the aesthetic is about unclearness), and (3) repetition (continuity).

3. Heretofore wabi-sabi has had no formal, systematic structure. Is the approach of this book intellectually legitimate? Sen no Rikyu, the highest wabi-sabi authority according to orthodox scholars, is alleged to have said that one grasps the purest essence of a rule or concept by understanding its totality. Then if one desires, the derivative forms may be modified to meet current needs. In a sense, that is what the author of this book is doing here with wabi-sabi.

4. Zen Buddhism originated in India and subsequently traveled to China in the 6th century A.D. where it developed further. It was first introduced into Japan around the 12th century. Zen stresses "direct, intuitive insight into transcendental truth beyond all intellectual conception." At the core of both wabi-sabi and Zen is the importance of transcending conventional ways of looking and thinking about things/existence. Nothingness occupies the central position in wabi-sabi metaphysics, just as it does in Zen.

5. Every *iemoto*-style business in Japan is organized in a pyramidal structure with the

iemoto at the top. A part of each payment that every student makes to his or her personal teacher for art instruction is kicked up the pyramidal ladder so that the *iemoto*, the hereditary leader (usually the eldest son), gets a cut. Today many of the *iemoto* families are enormously wealthy and have diversified their businesses into areas far removed from the strictly cultural.

6. Polarizing the world into "East" and "West" is a convenient communication shorthand, like using the names of famous people, events, and things, as symbols of culturally agreed upon generalizations. Particular caution should be exercised when characterizing Japan as "Eastern." Especially since World War Two, Western ideas and values have increasingly become Japanese ideas and values, resulting in the gradual supplanting of Japanese aesthetic concepts by those from America and Europe.

7. There are also some ironic compatibilities between modernism and wabi-sabi. In contemporary Japan, for example, one often finds wabi-sabi-style tearooms and restaurants housed within modernist glass and steel

buildings. Even stranger is that Kobori Enshu (1579–1647), a wabi-sabi tea master, is the reputed designer of Katsura Detached Palace (Katsura Rikyu) in Kyoto. This open-plan, unostentatiously decorated complex had enormous influence on the thinking of many early modernist architects in the West. Whether or not Enshu was in fact the designer, his influence permeates Katsura, making wabi-sabi indirectly one of the major inspirations of modernism.

8. Ideally the tea ceremony was a complex information ritual in which everybody present was supposed to participate. Much like a John Cage music composition with only basic instructions specifying procedure and methods, each new ceremony created new artistic circumstances that resulted in a new "piece." Because most people involved had considerable prior tea experience, their knowledge was built into the very structure of the event (artful design allusions to previous ceremonies, literary and informed conversations, etc.), so that each subsequent ceremony became ever more deeply and intricately layered.

9. The 16th-century tea room was much like the golf course of today for Japanese businessmen. It was where wealthy merchants cultivated new business contacts. It was also where warriors sought and consummated political alliances and celebrated battle victories. (All warriors during this period learned the art of tea.)

10. Many anecdotes, most of them probably apocryphal or greatly embellished, continue to circulate about instructive events in tea history. One such story is about Rikyu's "entrance exam" before being admitted as a student of the famous tea master Takeno Joo. Rikyu was asked to clean Joo's leaf-strewn garden. First he raked until the grounds were spotless. Then, in a gesture pregnant with wabi-sabi overtones, he shook a tree trunk, causing a few leaves to fall. Wabi-sabi, as evidenced here, is clean but never too clean or sterile. Virtually the same anecdote is also told wherein Rikyu is the master and his son the aspiring student. In this version it is Rikyu who shakes the leaves from the tree as a reprimand to his son, who has rendered the garden grounds completely leafless.

11. At first things wabi-sabi were materials Rikyu and his associates found in farm houses, on trips abroad, etc. Eventually, Rikyu became an "art director" and commissioned craftsmen to create original objects in this new sensibility.

12. Rikyu's minuscule farm-hut-style tea room and the use of unrefined utensils in reaction against the opulence of his time is sometimes compared to Marie Antoinette's playing shepherdess and milkmaid, attired in simple cotton dress and straw hat, in a simulated peasant's hut in a corner of the Versailles palace garden. In all likelihood, Rikyu's play was much more serious. Rikyu had an underlying aesthetic agenda whereas Marie Antoinette's interest was essentially novel entertainment. Legions of Rikyu's subsequent followers, however, were (and are) rich people playing poor, in ostensible wabi-sabi style, but closer to the spirit of Marie Antoinette than Rikyu. Some of their "simple" rustic tea huts, made of the finest materials using the most expensive craftsmanship, cost more than mansions. Their humble-looking tea utensils were also outrageously expensive.

13. It is difficult to know what Rikyu actually thought about wabi-sabi and tea practice since virtually all we know about his ideas comes through two secondhand sources. The most important document, the *Nanbo Roku*, was supposedly written after Rikyu's death by Nanbo, a Buddhist monk, student, and friend from their mutual home town of Sakai (near Osaka). But some scholars think it an artful forgery, for the only extant copy was too conveniently "discovered" by Tachibana Jitsuzan, a samurai and tea person, on the one hundredth anniversary of Rikyu's death. The other document, *Yamanoue Sojiki*, is a record of such things as motifs and objects used at Rikyu's tea ceremonies that were attended by his longtime student Yamanoue Sogi. Both books have been used to justify all manner of ideological positions relating to tea and wabi-sabi.

14. Another aspect of this practice is the belief, from Zen, that the body, not language, is the repository of knowledge and technique. Hence tea focuses on the rote learning of forms.

15. Communication between people, or human relations, seems to have been a very minor

part, if it existed at all, of Rikyu's idea of wabi-sabi tea. The *Nanbo Roku* admonishes tea practitioners *not* to attempt to synchronize their feelings with those of their guests unless it happens spontaneously. In other words: don't let the human connection prevent you from reaching and maintaining the highest wabi-sabi mindset possible. Objects and people are treated similarly in wabi-sabi. Wabi-sabi is not a humanitarian philosophy; nor is it about the sanctity of life, man's humanity to man, or good and evil.

16. Sabie (from *sa* = tea, *bi* = beauty, *e* = meet, meaning "meet the beauty of tea") is the name of the organization of progressive tea people referred to here. The head of Sabie is Masa-kazu Izumi, the second son (therefore *not* the future *iemoto*) of the largest tea school in Japan. Sabie's artistic direction is primarily influenced these days by Ikko Tanaka, one of the elder statesmen of Japanese graphic design and art direction, and Junji Ito, a celebrity critic and art coordinator.

17. The tangible Sabie results so far, tea rooms and utensils, have been exhibited primarily in

Japanese department stores. As yet there are few inklings of wabi-sabi. Most of the items produced hark back to a time in tea before Rikyu, that is, before the initial consolidation of wabi-sabi sensibility. They seem closest to the Japanese tradition of refined, elegant diversion and play (*asobi*).

18. Up to now, wabi-sabi has never been expressed in such a formal and highly ordered manner. Through imposing this "artificial" intellectual structure, the author feels wabi-sabi becomes much more comprehensible.

19. Another visual metaphor for things coming into and out of existence, leaving the subtlest of evidence, is the cherry blossom, one of the most potent (and cliched) images in Japanese culture. Every spring the cherry trees bloom for about a week at most. But a sudden rain or wind can cause the delicate pale pink flowers to fall away at any moment. During this brief window of opportunity, large and small groups of people spread mats and blankets under cherry trees throughout Japan. Instantaneously a place—the antithesis of a formal structure—and an event are created together. The

enduring and poignant (wabi-sabi) power of this image of the cherry blossom comes from our ever-present awareness of the ephemerality of it all. A moment before there were no blossoms. A moment hence there will be no blossoms. . . .

20. In the context of wabi-sabi "nature" means several things. It refers to the dimension of physical reality untouched by humans: things in their pure, original state. In this sense, nature means things of the earth like plants, animals, mountains, rivers, and the forces—sometimes benign, sometimes violent—of wind, rain, fire, and so on. But nature in the context of wabi-sabi also encompasses the human mind and all of its artificial or "unnatural" thoughts and creations. In this sense nature implies "all that exists," including the underlying principles of existence. In this meaning nature corresponds closely to the Western, monotheistic idea of God.

21. A perfunctory part of the tea ceremony as it exists today is paying formal attention to each object included in the ritual. This means attention not only to the details of the tea

bowls, tea container, water kettle, and the like, but also to such things as the container the flowers are in and even the charcoal used to heat the water. What was once a spontaneous occurrence is now rigidly scripted—there are specific rules about how and when to handle the objects and how and when to ask questions about the objects—but at least this forces you to pay attention to, and hopefully really "see," the very thing in front of you.

22. Translation by Toshihiko and Toyo Izutsu.

23. The earliest wabi-sabi tea utensils designated by Rikyu were anonymously designed and crafted everyday household objects: objects of absolutely no status. But status, it seems, manages to assert itself whenever given the chance, and almost immediately there developed a high-priced market for these heretofore ugly and obscure things. Once something becomes too valuable, too costly, it ceases to be wabi-sabi. It becomes, instead, only an expensive reminder of what was once a dynamic moment. This is not to say there are not many "quasi" wabi-sabi treasures in museums throughout Japan. But

they are only "shells," things that have the form and the look of wabi-sabi but no longer the true spirit.

For a few brief years in the late 1960s and early 1970s there was a Japanese art movement called Mono-ha ("school of things") that shared the wabi-sabi appreciation of things for this moment only. Mono-ha artists used ordinary natural materials like trees, rocks, and rope to create temporary installations. Part of the integrity of their work was its non-collectibility. (As a consequence, collectors and museums don't own any.) As one critic noted, "[They] rejected the notion of perfect, finished objects. Their sculptures were merely temporary confluences . . . not originals that would increase in monetary value."

24. Manufacturers and fabricators are continually striving to increase the predictability and uniformity of manufactured goods. Industrial design and architecture both rely on precise, finished drawings being provided to fabricators. If you make changes during manufacturing or construction, you get penalized with exorbitant overcosts. But many artists, and some designers, are bored with every-

detail-perfect objects. Things in process, like buildings under construction, are often more imagistic than the finished thing itself. Poetic irregularity and variability are difficult to mass produce, however.

Another factor conspiring against irregularity is the prevalence of Euclidean-based design models. Everything in the mass-produced realm is typically composed of perfectly straight lines, circles, curves, rectangles, and triangles. (These rigid geometric shapes, not coincidentally, have become the icons, the visual symbols, of the design profession itself.) The "laws" of shape and form in nature are more diverse. In the 1980 book *The Fractal Geometry of Nature*, mathematician Benoit B. Mandelbrot elucidates another geometry that can be used to mathematically describe irregular shapes and textures such as grainy, tangled, wispy, wrinkled, and the like.

25. Wabi-sabi is antithetical to the idea of "universal archetypes," the notion that certain prototypical objects can aesthetically function at any scale. From a wabi-sabi perspective the density of information contained within an object changes, as does the human relatability,

when the scale does. Certainly the design considerations of a cabinet and a house are different. Yet some architects treat the design of a building as if it were no more than a blown-up piece of furniture.

26. The aesthetic philosophy of Kyoto's oldest and most famous inn (the 300-year-old Tawaraya, $700 per night per person including two meals as of this writing), boils down to two unswerving wabi-sabi-like principles that, according to its owner are: (1) "No one object or element in any room shall stand out above any other" and (2) "Thou shalt not revere the old for old's sake. If it's new and it fits, use it."

Picture Captions
and Credits

Unless otherwise indicated, photographs are by the author.

PAGE 6—An example of funky wabi-sabi. The exterior facade (detail) of the Bombay Cafe and Okura sundries boutique (Daikanyama, Tokyo), composed of driftwood, recycled sheet and corrugated metal, and plaster.

PAGES 12–13—A leaf decomposing on the ground.

PAGE 14—Detail of unpainted wood siding, material common in single-family houses built in Tokyo circa post–World War Two through the 1950s.

PAGES 19–20—Ceramic containers by Kazuhiko Miwa. Art direction/photography by Gakuji Tanaka. Art direction/design by Ichiro Mitani.

PAGE 24—Residue around the weld of an iron pipe and an iron plate.

PAGE 30—A traditional farmer's storage hut of the type on which the wabi-sabi tea house is modeled (Nagano Prefecture, Japan, 1993).

PAGE *37*—Intersection of two mud and straw walls in a traditional Japanese room. This is typical of the photographic images used to convey traditional wabi-sabi.

PAGE *38*—A chair of expanded metal designed by Shiro Kuramata (1934–1991). A good example of a fusion of modernism (the industrial process, precision execution, geometric forms) and wabi-sabi (sense of nothingness and non-materiality, murky color, subordinate importance of utility). Photograph by Mitsumasa Fujitsuka.

PAGE *43*—Vegetable matter of indeterminate origin (detail). Photograph by Eiichiro Sakata. Art direction by Tsuguya Inoue. Courtesy of Comme des Garcons.

PAGE *44*—Intentionally rusted and corroded iron. Detail of a sculpture by Ajiro Wakita. Photograph by the artist.

PAGE *47*—A leaf decomposing on a sidewalk.

PAGE *48*—A well-worn plumb line and brass bob (detail).

PAGE 53—A volunteer garden at the intersection of two remaining walls of a demolished building in downtown Tokyo. Photograph by Koichi Inakoshi.

PAGE 56—A tree (Tokyo). Wabi-sabi is not merely virgin nature of certain characteristics. Man must intercede to at least "frame" it, giving it a distinguishing context. A photograph provides such a frame. Photograph by Koichi Inakoshi.

PAGE 58—The exterior of a wabi-sabi tea hut in Kyoto. Photograph by Koichi Inakoshi.

PAGE 60—a tea bowl by Raku Kichizaemon. Photograph by Koichi Inakoshi.

PAGE 63—A sweater (detail) by Comme des Garcons (1982–1983 season) supposedly created by programming the loom to create a fabric with randomly placed holes. Photograph by Peter Lindbergh.

PAGES 64–65—The interior of Chanoha, a 180-square-foot tea room located in a corner of the basement of the Matsuya Department store in Tokyo. The back wall is a mosaic composed of

metal in various states of tarnish and rust. The foreground counter is (right) sandblasted concrete and (left) wood. This subdued and delicately articulated corner of an otherwise frenetic commercial environment provides an easily accessible moment of wabi-sabi.

PAGE 66—An Indonesian day bed (detail) of discarded wood polished to a glowing sheen through use. One of many pieces of Southeast Asian wabi-sabi furniture in the offices of the Jurgen Lehl Co. (Tokyo).

PAGE 69—A mud wall (detail) in Mali, West Africa. Photograph by Cindy Palermo. Courtesy of Hanatsubaki Magazine.

PAGE 70—Three dried fish.

PAGE 73—A water-borne trail of rust emanating from a nail in wood.

PAGE 74—A flat rice cracker with an embedded small fish. This kind of cracker and variations using other kinds of sea food, mushrooms, and assorted edible delicacies are common in the food halls of virtually all large Japanese

department stores. These food halls are the most likely place to find wabi-sabi artifacts in contemporary Japanese life.